**Gaylen
Gerber**
January 20-
February 29,
1992

**The
Renaissance
Society
at the
University
of
Chicago**

Acknowledgments
Susanne Ghez
Director

The Renaissance Society takes pride in presenting the work of Gaylen Gerber, a Chicago artist whose work contributes substantially to a discourse about painting which is international in its breadth and historical in its depth. Few topics within the field of contemporary art are as intimidating as the ontology of painting. As Jan Avgikos' critical essay attests, Gerber's work situates itself within a very complex history of contemporary painting. This history has been a series of limits which have in turn defined the medium, making painting an historical act and by extension a philosophical one. Gerber's manner of repeatedly combining the monochrome and the still life questions the possibility of painting to achieve the type of closure a philosophy of it would predict, were it not for the very act of painting itself. Seeing never progresses to the blind faith associated with believing, but instead remains a continual perceiving.

The Renaissance Society has a long tradition of presenting challenging contemporary art. Since the move to its current location in 1979, many artists have engaged the physical space of the gallery to advance and expand their artistic investigations. In the decade preceding the Gaylen Gerber exhibition, artists Daniel Buren, Jeff Wall, Gunther Förg, Steven Prina, Niele Toroni, Hirsch Perlman, Michael Asher and Maria Nordman realized exhibitions wherein the architecture of the space became an active component of the work. For his exhibition, Gerber directed the staff to completely wall off all but the first third of the space. He then installed his paintings, edge to edge, left to right, across the new 80 foot wall. Confrontational, assertive and unrelenting, the installation demanded the interaction of the viewer. Staging a physical interaction between the architectural layout of the space and the paintings, Gerber pushed forward his investigation of perception and truth, opening the door to future possibilities.

The Society is particularly indebted to Jan Avgikos for her essay which analyzes the philosophical and perceptual issues about the nature of painting presented by Gerber's work. Her collaboration with the artist in this endeavor provides us with privileged insight.

We are especially appreciative of the cooperation and generosity of the lenders: Armand and Ewa Bartos, New York; Jane Gekler, Los Angeles; Philip and Eugenia Gerber, New York; Lisson Gallery, London; Robbin Lockett Gallery, Chicago; Rosemarie Schwarzwalder, Galerie Nächst St. Stephen, Vienna; and C. Bradford Smith, Chicago.

This project is made possible in part through the generous support of Board member Howard Stone and his wife, Donna Stone. They deserve special recognition for their support of the catalogue and the artist's work. We would also like to express our appreciation to The Elizabeth Firestone Graham Foundation for its ongoing support of Renaissance Society publications. This support is the bedrock and lifeline of The Society's publication program. Additional individual support for the catalogue comes from Michael and Eileen Cohen, Joel and Zoe Dictrow, John Robertshaw III, and C. Bradford Smith.

Jason Pickleman and Leslie Bodenstein of JNL Graphic Design, Chicago, designed the publication, Jean Fulton provided careful editorial assistance and Tom van Eynde photographed the installation at The Society. We thank them for their tireless patience and careful work. At The Renaissance Society, thanks are extended to Randolph Alexander, Development Director; Hamza Walker, Education Director; Patricia Scott, Office Manager and Bookkeeper; Karen Reimer, Preparator and Registrar; and Paul Coffey, Steven Drake and Kristine Veenstra, Work/Study Assistants.

The exhibition *Gaylen Gerber* was supported in part by The National Endowment for the Arts, a federal agency, the Illinois Arts Council, a state agency, the CityArts Program of the Chicago Department of Cultural Affairs, a municipal agency, and by members of The Renaissance Society. Indirect support was received from Austin Bank of Chicago, The First National Bank of Chicago, The John D. and Catherine T. MacArthur Foundation, and the Sara Lee Foundation.

Finally, I would like to thank Gaylen, whose manner of working, not to mention his presence locally, has kept the most theoretical and rarefied issues surrounding painting from ever seeming too distant both geographically and conceptually.

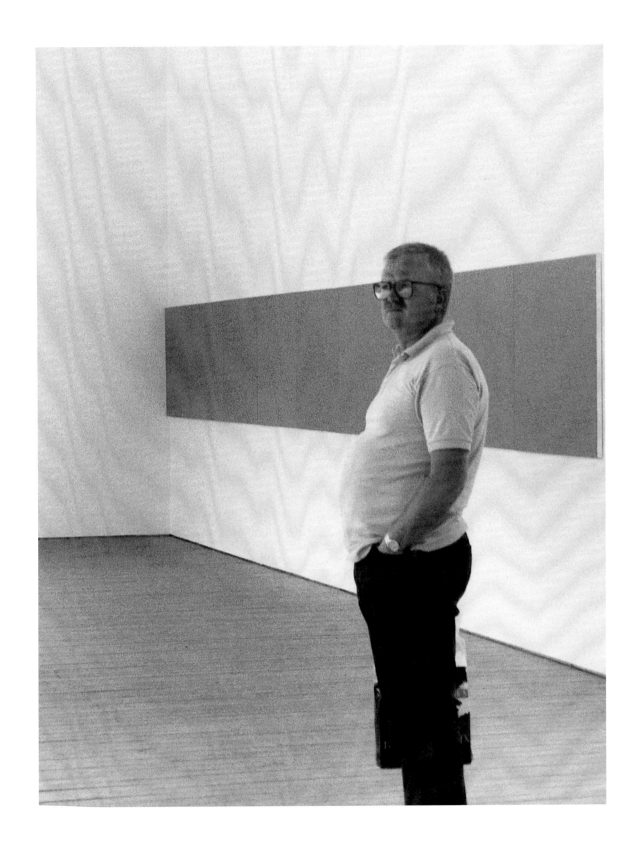

I know, but when you ask me I don't.[1]
Jan Avgikos and
Gaylen Gerber

What is the role for painting today?
This question, which circulates periodically, presumes much and seems an appropriate introduction to the work of Gaylen Gerber.

Among other things, the question presupposes a definite action or solution for painting within a historical context. It also suggests a distillation of painting's historical location as the meaning of that context is formulated. This assessment of painting is consistent with the line of inquiry posited since Minimal and Conceptual art that concludes in the logical and practical devaluation of the contextual relevance of painting's internal relational aspects, aspects that once comprised the primary dialectical relationship of artistic involvement and which defined painting's significance.

The issues that arise relative to this observation are analogous to considerations that arise in experiencing Gaylen Gerber's paintings. These may help us to articulate the arbitrariness of the referential boundaries that regulate perception, as well as to distribute within the situation of the paintings themselves some of our well-rehearsed responses regarding the value of painting.

Gerber's paintings, precisely because of their mitigating quality, are well suited to affect an encounter in which we can contemplate, as well as distinguish, the aesthetic/social boundaries that serve as a basis for a viewer's perceptions and for art's historical methodologies. By organizing, in actual terms, the relationship between the language of the object and the language of the viewer, Gerber's paintings enable us to moderate the contextual delineations with which we constitute meaning and to articulate for both artist and viewer a sense of individual distinctions. These general and particular aspects are delineated through practical participation. Paradoxically, this participation in relation to the work has the effect of dispersing the prevailing patterns of aesthetic activity by restricting points of view. Relying upon the interaction between our self conceptions and the whole of the cultural situation, Gerber's paintings make apparent the uncertainty of any one position exclusive of the next, precluding the paintings from becoming either opaque or transparent models of any singular order or activity.

All instances of our structuring of these paintings then serve as a mirror to each individual's separation of the generalized intentions of our frames of reference from the seemingly transparent ground of corporeal experience; each instance also serves as a site for synthesis. Every formulation for interpretation (and its accompanying frame of reference) is, then, dependent for its definition upon the viewer's active involvement relative to the paintings. Likewise, alternate formulations for the paintings may be different, yet consistent with one another, depending upon the viewer's form of activity.

While we may be predisposed towards affinity with one or more frames of reference, Gerber's work facilitates an articulation between, and fluidity among, various responses. The work makes apparent our seemingly inherent flexibility in utilizing, modifying, ignoring, and discarding any number of positions that characterize our coming to terms with experience. Unsettling the relationships between perception and memory, and orientation and inclination, are only the preliminary relationships which the paintings initiate with the viewer. Considered problematic in one formulation for interpretation, the value and function of these relationships may be altered considerably in another. Delineations then would seem to be as much a physiological response to experience as they are discursive aspects of the rules we use to define those very perceptions.

Throughout the nineteenth century and into the twentieth, reception theorists conceived of an equal partnership involving artist, object, and viewer, a partnership that made clear the demarcations separating them one from another, yet without ever questioning the social component of space. Accordingly, a viewer's engagement was perceived as being the imaginative transposition of the "spaces" of experience onto the "space" of the canvas. The aesthetic situation itself was perceived as though occurring in a vacuum, effectively excluding the social. As such, a work of art was considered to be static, with any variance in assessing value within social circumstances to be understood as a mistake lacking in aesthetic discrimination. The underlying presumption was that a single uniform model for artistic activity existed, against which experience could be objectively measured.

Beginning with early Modernism, the aesthetic situation has been continually reformulated, moving away from the position in which aesthetic values are immutable. Artists developed alternate positions in which no single true or uniform model of artistic activity

1. "I know, but when you ask me I don't" paraphrases Augustine's reply when queried, "What, then, is time?" The answer implies an equilibrium between body and mind that informs our broadest understanding of the world, and that once unbalanced becomes inaccessible.

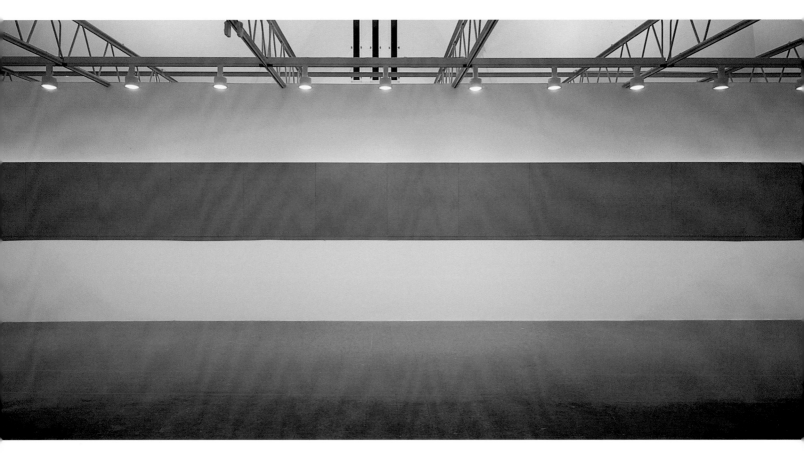

Installation
The
Renaissance
Society,
Chicago
1992

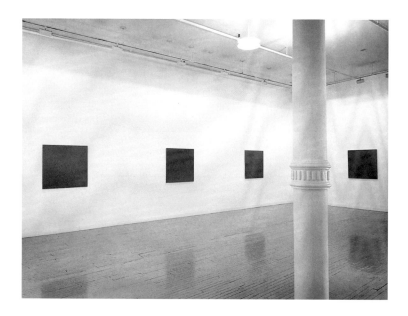

**Installation
Wolff Gallery,
New York
1988**

existed; instead, they formulated responses which began to recognize and reconcile all evaluations as mediated. Any number of evaluations might apply to a work of art. The resulting inability to discriminate an "appropriate" measure with which to assess value in art led to a shift in emphasis towards the consideration of art as a nexus of contextual structures and away from an emphasis upon the object and its distinctions as discrete. In reaction, a re-emphasis has sometimes been placed upon individual quality irrespective of contextual distinctions. Consequently, the location and relevance of the limitations concerning how we assess value continue to be points of interest and contention.

The "other side" of any division between positions in this discourse is vitiated by focusing on the likelihood that the activities of delineation and categorization may themselves be fundamental to the way we function. To observe ourselves in the act of both establishing and transgressing boundaries, conscious of our actions, is to acknowledge ourselves as active agents in the process of continually creating and recreating our reality. The flexibility inherent in this process has the effect of bringing to light our uncertainty concerning whether perceived configurations and categorization differ from those that are exhibited in the paintings.

Gerber's work hypostatizes this propensity to delineate difference by mirroring, or even designing, the conditions for experiencing a series of categorical boundaries. These conditions are presented as conceptual and perceptual options. What is thereby brought into consideration is not only what we see and what we believe but also the extent to which experience might be shared between viewers. At first glance, Gerber's paintings may appear to be only monochromatic, and to be so in the most conventional sense: no composition, no extra-referentiality, nothing to interrupt the logic of a purely phenomenal "art" experience.

Installed in this instance at the Renaissance Society, end-to-end in a continuous/contiguous line comprised of some twenty-five canvases, each thirty-eight inches square, and each reiterating the singular premise of a gray, monochromatic surface, the paintings appear to reference themselves, and only themselves, ad infinitum. Despite their being made by hand and thus being gesturally distinct from one another,

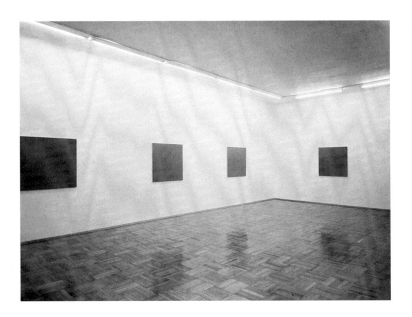

**Installation
Galerie Nächst
St. Stephan/
Rosemarie
Schwarzwälder,
Vienna
1989**

they give the appearance, from one gray field to the next, of being virtually identical. The paintings, in their self-referential sameness, suggest the redundancy of a tautological program. Within the paintings' contextual framework – whether that be termed a system, sequence, or repetition – part and whole are interchangeable. Given any regular arrangement, whether the paintings number two or twenty or two hundred, their sum is never more than one. Complementary and contradictory properties such as complete/incomplete, beginning/end, open/closed, chronological/achronological, which are brought into question by the formulation of a collective entity, must also be considered as being properties belonging to a single painting.

This formulation calls us to consider Gerber's paintings as being prime paintings. Each has itself and unity as its only factors. We can acknowledge that each of the paintings is unique in its similarity to or difference from all of the others without excluding the possibility that all of the paintings may also be identical. As the individual conflates with the collective, notions of origin, progression, consistency, and closure lose their relevance.

The seemingly contradictory aspects of sameness and difference realized in the paintings parallel the relationship established between these particular monochromes and the practice of monochrome painting as reiterated throughout the twentieth century. Again and again Gerber's paintings repeat size, color, gesture, surface density, and working progression. The paintings as sign are as unconfirming of "regression" as of "progression" – words that seem so appropriate in describing the persistent practice of monochrome painting as well as being central to its original premises.

Among Modernism's highest ambitions was its aspiration to pure aesthetics. It strove to attain an ideal that would privilege nothing beyond its own visual and material properties, and that would stand apart from all extra-referentiality. Monochrome attempted a degree of freedom, not only from pictorialism, but also, for a time, from the ambiguous relationship between sign and symbol. Indexed to the paradigms of the tautological "thing in itself" and "pure visuality," the purpose of the monochrome was unalloyed singularity.

Paradoxically, monochrome painting, through its own proliferation and our collective awareness of it, acquired another status. Becoming itself a quotation of

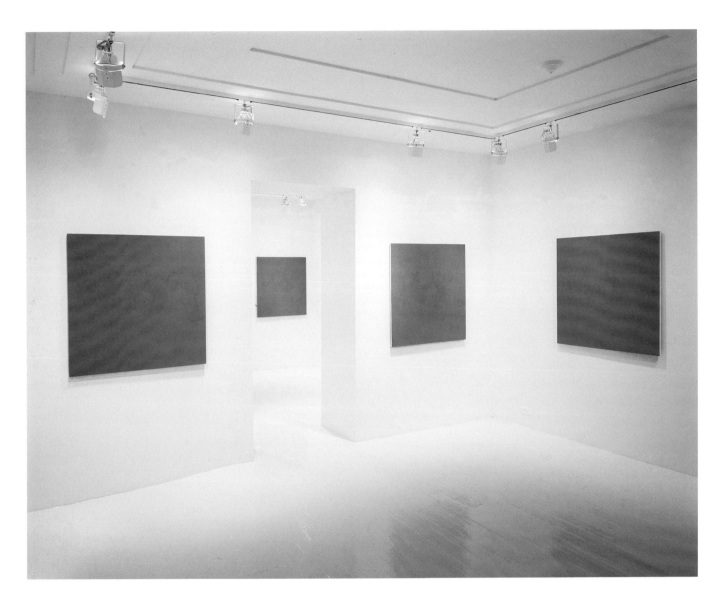

**Installation
Robbin Lockett
Gallery,
Chicago
1988**

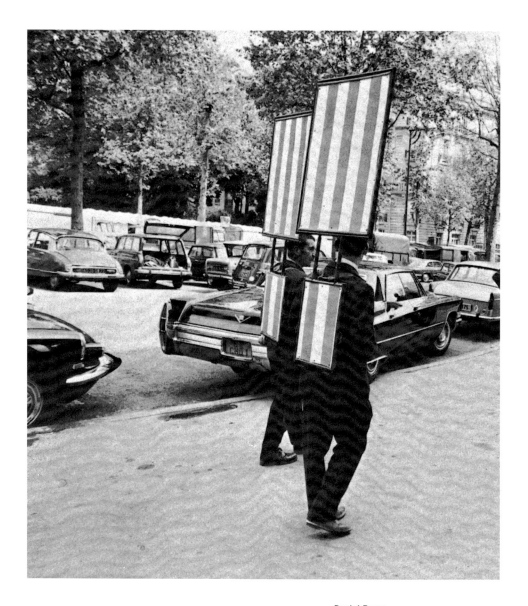

Daniel Buren
Photo-Souvenir:
Sandwichmen
Paris, France
April, 1968

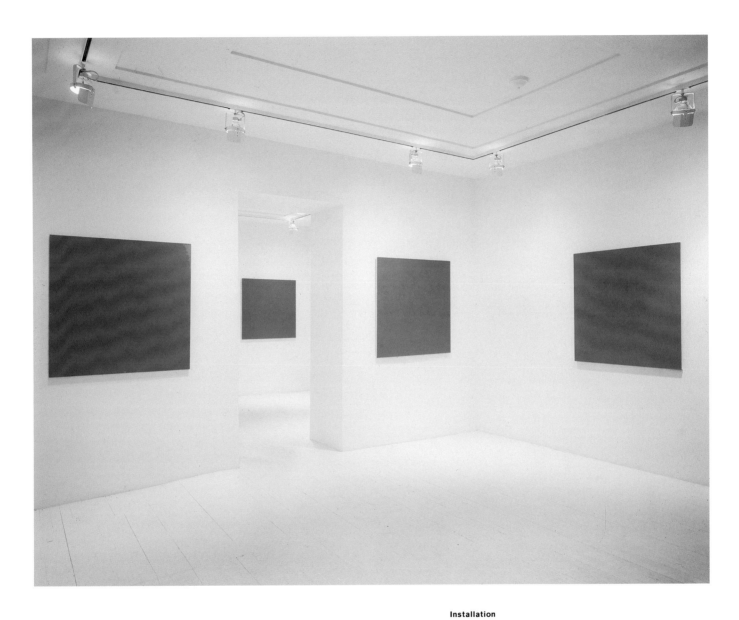

Installation
Robbin Lockett
Gallery,
Chicago
1989

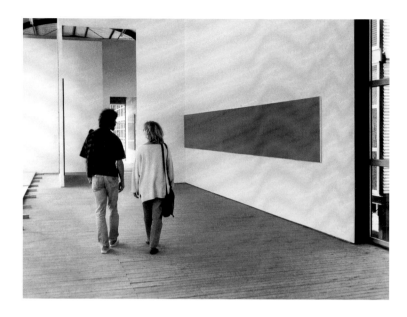

**Installation
Documenta IX,
Kassel
1992**

conventional practice, it was both sign and symbol of its own identity. Over time, the monochrome came to function as both a non-objective painting and a representation of itself. The proposition that painting may be simultaneously non-objective and representational is integral to the debate of twentieth-century art. How complicated that premise has become is demonstrated by its continual formulation and reformulation throughout the century. The emergence of an ideological basis for each of these two seemingly contradictory trajectories only enhanced the polarization in which one was privileged over the other.

From the onset of Modernism, the circumstances presaging such an absolute dichotomy between representation and presentation exhibited the same simultaneous sign/symbol ambiguities as those in which the painterly process itself had, for some time, been enmeshed. We might consider El Lissitzky's "Proun" paintings, for example, as precursors to Gerber's practice, where such ambiguity is an explicit function of opticality, altering perception relative to a viewer's change in position. Looked at from one attitude, Lissitzky's geometric configurations adhere to the literal flatness of a material plane. Seen from another, they appear as geometric volumes within illusionistic space. The instability of the frame of reference is no less evident in the Suprematist paintings of Kasimir Malevich. Here it is an iconographic uncertainty, rather than an optical alternative, that contradicts the resoluteness of intersecting planes as being anything other than pure form. And later, in a manner seemingly designed to exhaust polarity, Ad Reinhardt conflated both optical and iconographic conventions in "one" painting, which he produced over and over again, designated continually as the "last" painting. Within the structure of each "last" painting, distinctions between form, symbol, and referent can be discerned by comparison of the opposing horizontal and vertical axes but not in their undifferentiated combination.

Adopting a similarly repetitive practice and conflation of aesthetic conventions, Gerber implies continuity within our present performance of painting's normative structures. Gerber's treatment of contradiction as not necessarily implying conflict constitutes an alternative to our traditional use of categorical measures. The effect is to disperse restriction to the

dichotomy inherent in dialectical discourse.

In contrast, a good deal of contemporary practice continues to frame referential content as problematic. Post-Modernism initially employed Modernist practice to exploit its institutional status as well as to demonstrate an ineffectual ideology. In so doing, Post-Modernism sustained the Modernist dichotomy, redoubling one of the most stalwart percepts of Modernist dogma: the problem of sign-symbol ambiguity underlying abstraction. Thus recognition of this concern was postulated in terms of an ambivalence which served as a basis for exaggerated parody, as well as irregular separations and dissociations between sign and symbol.

Post-Modernist strategies of appropriation and simulation make apparent that painting in its creative, intuitive, and meta-rational dimensions, along with its socio-political institutions and practices, was to be regarded with increasing ambivalence. Post-Modernism was inclined to define ideas of reception in the limited terms of (to borrow Fredric Jameson's phrase) external, late-capitalistic "culture logic." Consequently, the potential for painting to carry personal expression was diminished severely, to the detriment of all possible subjective performative engagement. Painting was treated as being little other than a material object, freighted with a heavy record of past activity and functioning in the world as any other commodity. Despite a strategic reformulation of Modernist practice, with emphasis on the social status of the object and the space in which it is contextualized, Post-Modernism continued to question painting and its interpretation within the sign/symbol paradigm of Modernist theory and practice.

To the extent to which his work utilizes disparate institutional models, Gerber's paintings can be related to the visual-contextual strategies of Post-Modernism. Various aspects are readily apparent: the scrutiny of identity that results from the doubling of images; the tautological framework; the reductivist practice; the attention to norms and their contextualization. In a manner not intended by most Post-Modern critical thinking, however, Gerber's work engages our sense of intimacy. The subtlety of "subjective," idiosyncratic, and sometimes unreasonable participation prompted while viewing the paintings is integrated with a lessening of differentiation in the paintings themselves.

Gerber's paintings continually direct us to the intentionality of our own activity, to our own configuration of the situation, helping us to realize the loop comprised primarily of our perceptual processes and our formalized systems of reasoning. Boundaries are recognized as being permeable, and are seen always in relation to their determination by the viewer. What is at issue is not the legitimacy of individual boundary delineations but, instead, attachment to these interpretations. We accommodate the distinctions and paradoxes that Gerber's paintings elicit to the precise extent to which we enter into their play. This play is essential in redistributing our focus from one projected towards the paintings to one that is inclusive of the paintings. In this way Gerber's practice correlates comprehension with actual practice.

Initially the paintings appear to be visually unadulterated. They seem to be (and arguably are) monochromes. But they are also representational still lifes. Consistent with the tautological model of monochrome painting, the schematics of the still life do not vary from one painting to the next or from one year to the next; but the perceptual translation of the experience of the paintings will differ from one viewing to the next and from one viewer to another. One encounters the paintings and then recognizes them as either a monochrome or tonal patterning. Afterwards, to distinguish or to classify becomes more consciously a matter of the viewer's choice; it will vary among viewers according to an individual's faculty in identifying the unified field as being also the compositional components of the still life.

Opinions vary. Some viewers may experience the patterning of the still life and be able to distinguish between it and the monochrome immediately, while others may never experience it at all, and yet others may follow the initiative of a text or conversation. The extent to which a viewer is able to differentiate the still life from the monochromatic field makes apparent each viewer's distinctly qualitative experience. To distinguish within the subtle tonal modulations of Gerber's surfaces a compositional or pictorial pattern requires a shifting of the eyes' focal depth of field and a constant re-positioning of the body relative to the surface of paintings. By bringing representation into view through the actual shifting of the viewer's position, the aesthetic situation becomes altered, leaving the surface continually subject to further consideration and giving narrativity a practical temporal expression.

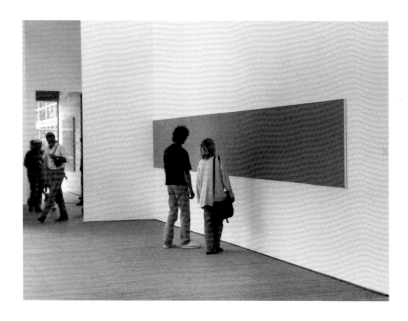

**Installation
Documenta IX,
Kassel
1992**

Counterpart to the perceptual engagements of Gerber's work are a set of conceptual displacements that are capable of exploring the referential structurings of those perceptual processes. Beginning with the parallel between the canvas itself and the wall on which it hangs, Gerber's work recognizes representation, and representation's ability to enable a discrete element to serve as an equivalent for a larger context, simultaneously reflecting a particular moment while remaining contemporaneous with its context.

Within Gerber's work these displacements are employed and collapsed in a manner analogous to aspects of Daniel Buren's questioning of categorization. This occurs most specifically in relation to the artists' concerns with pictorialism and the permeability of referential frameworks. By simultaneously fulfilling the prerequisites of descriptive and cognitive categories both artists indicate the arbitrariness of aesthetic boundaries that regulate vastly different social functions. The resulting oscillation between sign and symbol, and between part and whole, serves as a metonymic device directing our attention to the condition of art itself as a cultural construct. This suggests that our assignment of signification neither precedes nor follows our assignment of descriptive and cognitive categorization, but is established at the moment of indicating boundaries.

Gerber's paintings draw from this relationship with Buren's work and the shared discourse constituted and reformulated by successive generations of artists relative to alternate, contradictory, and ambivalent formulations of signification. But the delineation of these formulations in Gerber's paintings remains finally, and intentionally, unresolved. Gerber regards both interpretation and perception as not substantiated by what are ultimately malleable boundaries contingent upon our participation. Consequently, within Gerber's practice numerous positions and seemingly contradictory representations are supported as points of view relative to each location. By calling upon the active participation of the viewer to manifest these contrary aspects, the paintings avoid maintaining discrepancies between sign and content for their evaluation without excluding rhetoric and history. This is apparent in the way we become aware of the potential semantic value of Gerber's paintings as sign. We experience the indifference between our expectations of the paintings conventional value and their value

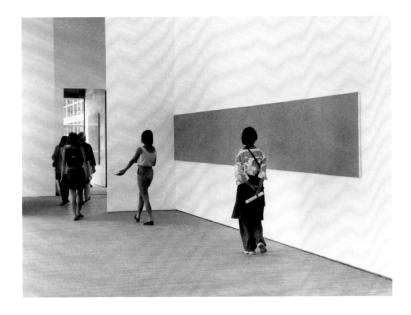

Installation
Documenta IX,
Kassel
1992

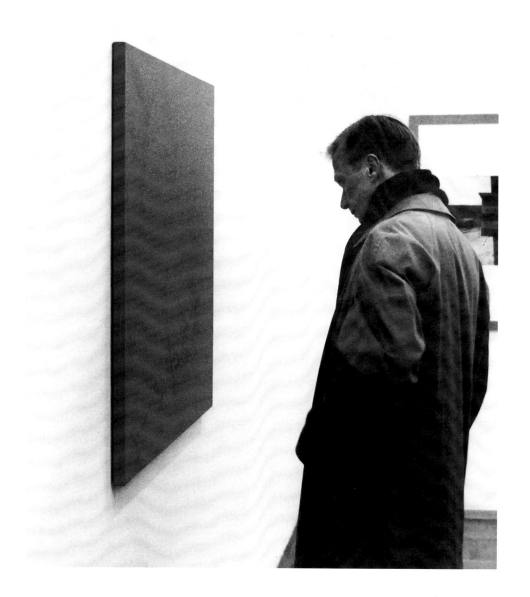

Installation
Galerie Nächst
St. Stephan/
Rosemarie
Scharzwälder,
Vienna
1994

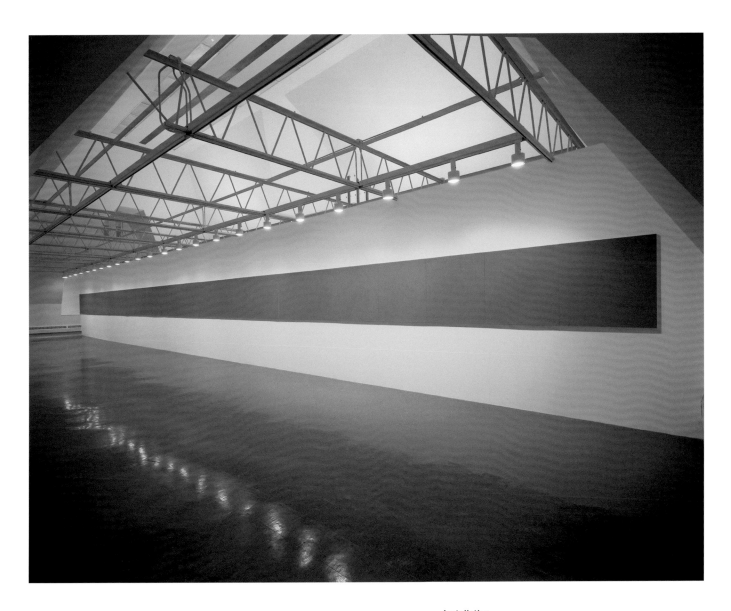

Installation
The
Renaissance
Society,
Chicago
1992

within a specific situation rather than the difference experienced between these two aspects of value. The uncertainty of this relationship is essential to Gerber's work.

Finally, there is no indication in Gerber's practice of a striving towards another level of response. Linking the clarity of our conscious awareness with our bodily activity, the paintings dispose us towards considering as "subjective" that which we commonly perceive as "objectively" external. What Gerber presents then is a relatively stable style growing out of our usage and conforming with established and agreed-upon formal standards. Very much present is our sense of individual experience in relation to these conventions. From this position the value of artistic convention remains variable. The very nature of the work acknowledges this sense of individualized experience, abetted by our aptitude for formulating various responses, one alongside another, each having association with potentially different models of activity. As such, the paintings function as a recognition of our various interpretive processes. The synthesis of these processes is considered a practice, an actual performance of watching that perhaps can never finally be realized, that must remain tentative.

Installation
Galerie Nächst
St. Stephan/
Rosemarie
Scharzwälder,
Vienna
1994

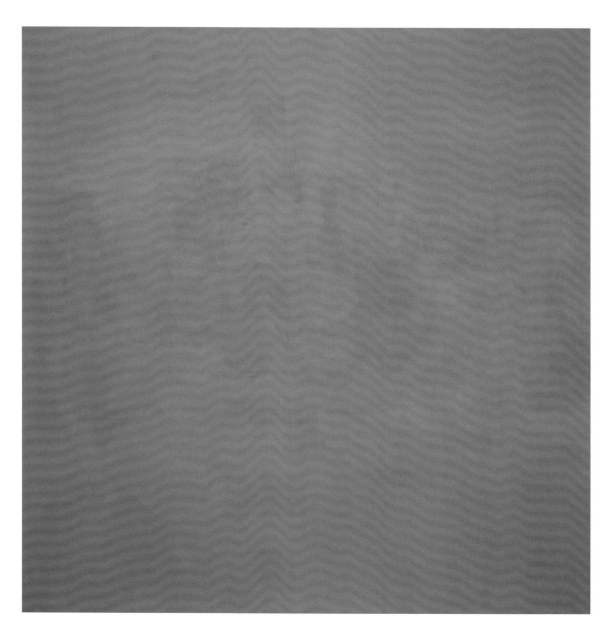

Untitled
oil on canvas
38" x 38"

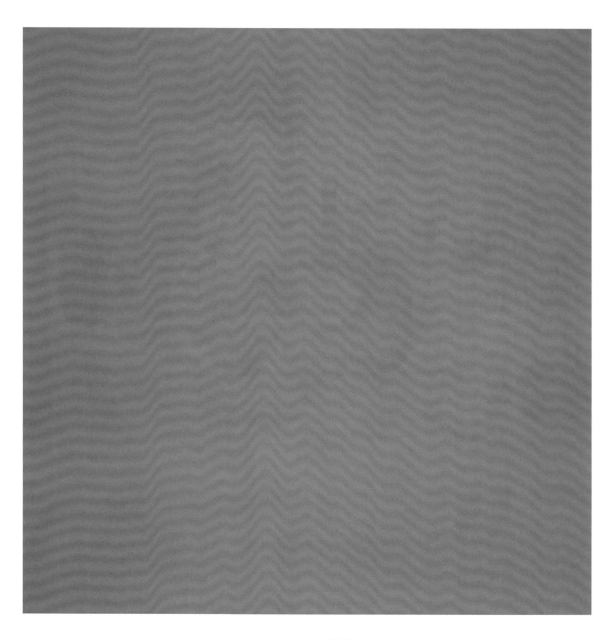

Untitled
oil on canvas
38" x 38"

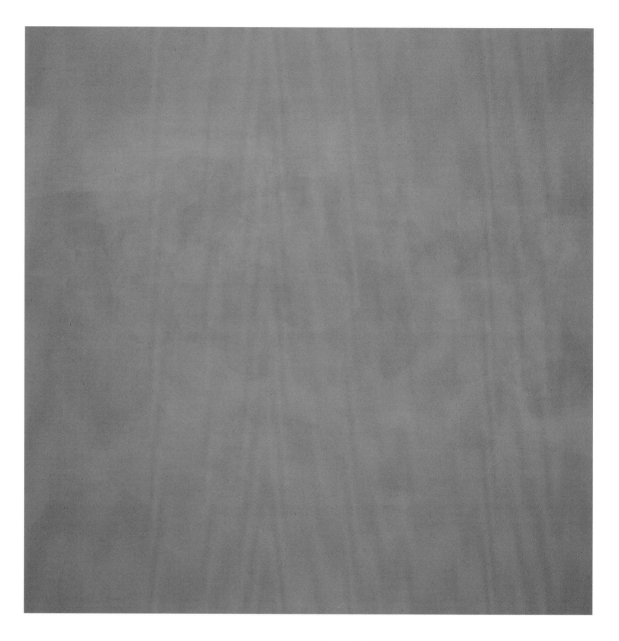

Untitled
oil on canvas
38" x 38"

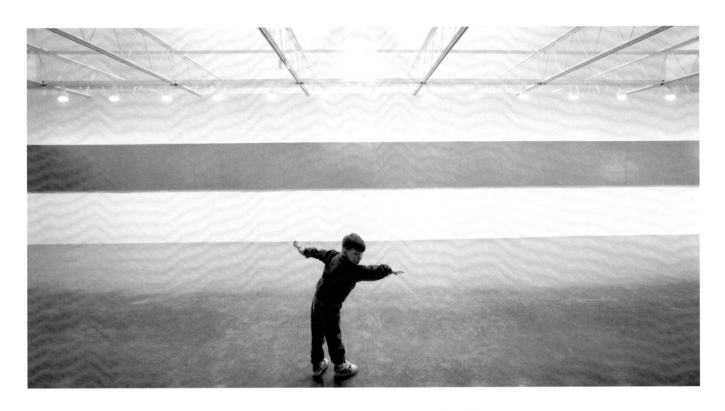

Installation
The
Renaissance
Society,
Chicago
1992

Gaylen Gerber
Biography

Born

1955 McAllen, Texas

Lives in Chicago

Solo Exhibitions

1994

Nicole Klagsbrun Gallery, New York, NY
(with Joe Scanlan)

1992

Michael Kohn Gallery, Los Angeles, CA
Wooster Gardens, New York, NY
The Renaissance Society at the
University of Chicago, Chicago, IL (catalogue)

1990-91

Robbin Lockett Gallery, Chicago, IL (catalogue)

1990

Le Casa d'Arte, Milan, Italy (catalogue)
Wolff Gallery, New York, NY
Shedhalle, Zurich, Switzerland (catalogue)

1989

Galerie Nächst St. Stephan/Rosemarie
Schwarzwälder, Vienna, Austria (catalogue)
Robbin Lockett Gallery, Chicago, IL

1988

Wolff Gallery, New York, NY
Robbin Lockett Gallery, Chicago, IL

1987

Grey Art Gallery and Study Center
at New York University, New York, NY

1985

vanStratten Gallery, Chicago, IL

1980

One Illinois Center, Chicago, IL

Selected Group Exhibitions

1994

Painting, Rhona Hoffman Gallery, Chicago, IL
Painting, Domaine de Kerguéhennec,
Centre d'Art Contemporain, Bignan-Locminé,
France (catalogue)

Gaylen Gerber, James Welling, Angela Grauerholz,
Galerie Nächst St. Stephan/Rosemarie
Schwarzwälder, Vienna, Austria
After and Before, The Renaissance Society at the
University of Chicago, Chicago, IL

1993

New Conceptual Work, Feigen Gallery, Chicago, IL
*Drawings: Abstrakte Malerie Zwischen Analyse und
Synthesise*, Galerie Nächst St. Stephan/Rosemarie
Schwarzwälder, Vienna, Austria
Works on Paper, Curt Marcus Gallery, New York, NY
De la Main à la Tête, l'Object Théorique, Le Domaine
de Kerguéhennec, Centre d'Art
Contemporain, Bignan-Locminé, France (catalogue)
Range of Colors, White Columns, New York, NY

1992

Documenta IX, Kassel, Germany (catalogue)
Abstrakte Malerie Zwischen Analyse und Synthesise,
Galerie Nächst St. Stephan/Rosemarie
Schwarzwälder, Vienna, Austria (catalogue)
From America's Studio: Drawing New Conclusions,
Betty Rymer Gallery, Chicago, IL

1991

David Cabrera/Gaylen Gerber/Mitchell Kane,
Trans Avant-Garde Gallery, San Francisco, CA
Group Exhibition, Galeria Anselmo Alvarez,
Madrid, Spain

1990

Strategies for the Last Painting, Wolff Gallery,
New York, NY and Feigen Gallery, Chicago, IL
(curated by Saul Ostrow, catalogue)
Drawings, Nathalie Karg Gallery, New York, NY
Drawings, Paula Allen Gallery, New York, NY

1990-91

*Mentalitaten un Konstructionen in Arbeiten auf
Papier*, Galerie Nächst St. Stephan/Rosemarie
Schwarzwälder, Vienna, Austria

1989

Group Exhibition, Robbin Lockett Gallery,
Chicago, IL
Problems with Reading Rereading, Rhona Hoffman
Gallery, Chicago, IL

Material Matters, Art Center Gallery, College of DuPage, Glen Ellyn, IL
Chicago Works: Art from the Windy City, Bruce Gallery, Edinboro University of Pennsylvania, Erie Art Museum, Erie, PA (catalogue)
Mediated Knot, Robbin Lockett Gallery, Chicago, IL (co-curator)
Prima Vision, Milano Internazionale d'Arte Contemporanea, Milan, Italy (catalogue)

1988
Drawings, Robbin Lockett Gallery, Chicago, IL
Looking Out, Rockford Art Museum, Rockford, IL
Tim Ebner/Gaylen Gerber/Allan McCollum, Ricky Renier Gallery, Chicago, IL

1987
New Chicago: Quiet and Deliberate, Tangeman Fine Arts Gallery, University of Cincinnati, Cincinnati, OH
Nourishment, Beacon Street Gallery, Chicago, IL
Group Exhibition, Center for Contemporary Art, Chicago, IL
Wet Paint, Robbin Lockett Gallery, Chicago, IL
July, Wolff Gallery, New York, NY
Invitational, Damon Brandt Gallery, New York, NY
The Non-Spiritual in Art/Abstract Painting 1985-???, 341 West Superior, Chicago, IL (catalogue)
Group Exhibition, vanStraaten Gallery, Chicago, IL

1986
Group Exhibition, vanStraaten Gallery, Chicago, IL
Group Exhibition, 30 South Wacker, Chicago, IL

1985
Invitational, State University of New York, Brockport, NY
Group Exhibition, Illinois Arts Council Gallery, Chicago, IL
Group Exhibition, vanStraaten Gallery, Chicago, IL

1980
Fellowship Exhibition, The School of the Art Institute of Chicago, Chicago, IL

1995
Green, Alison. "Towards the Real: New Abstractionists in America," *Vytvarne Umeni*, Special Issue no 1 & 2

1994
Zacharopoulos, Denys. "Domaine de Kerguéhennec"
Kruntorad, Paul. "Wildschwein, Schinkenrolle, Abstraktion," *Der Standard*, May 6
Borchhardt-Birbaumer, Brigitte. "Gerissen Gefugtes und Graues," *Wiener Zeitung*, April
"Galerie nachst St. Stephan," *Die Presse*, April 7
"Gaylen Gerber, Angela Grauerholz und James Welling," *Vernissage*, April
Artner, Alan. "Two decades is time enough for Renaissance Society show," *Chicago Tribune*, April 8, sec 7, pg 42
Glatt, Cara. "Renaissance Society finds its place in time," *Hyde Park Herald*, April 6, pg 9

1993
Artner, Alan. "Sharp conceptual show dares to be different," *Chicago Tribune*, January 22, sec 7, pg 56
Bouloutzas, Antonis. "Domaine de Kerguehennec – the unknown magnitude," *Arti*, November/December, vol 17, pg 67-95
____. "From the hand to the head, the theoretical object," *Arti*, November/December, vol 17, pg 96
____. "A conversation with Denys Zacharopoulos and Antonis Bouloutzas," *Arti*, November/December, vol 17, pg 97-113

1992
Kirshner, Judith Russi. "Reviews: Gaylen Gerber," *Artforum*, Summer, vol XXX, no 11, pg 114
Snodgrass, Susan. "Gaylen Gerber at the Renaissance Society," *Art in America*, July, pg 114
Hixson, Kathryn. "Chicago in Review: Gaylen Gerber" May (unpublished)
Myers, Terry R. "Route 66 to Kassel," *Fortt/Myers Publication*, no 1, June
Adcock, Craig. "Gaylen Gerber," *Tema Celeste*, May/June
Glatt, Cara. "Painting demands patience from viewers," *Hyde Park Herald*, February 19, pg 19

Hanson, Henry. "Art Works," *Chicago Magazine*, April, vol 41, no 4, pg 22

Artner, Alan. "Gerber paintings bring opposites to light," *Chicago Tribune*, February 7, sec 7, pg 67

Scanlan, Joe. "Focus on painting" Newsletter, The Renaissance Society at the University of Chicago, Winter, pp 1-2

1991

Searle, Adrian. "Art: Preview," *Time Out* (London), November 20-21, pg 41

Stonitsch, Lonnette. "Curiouser and Curiouser," *Exeter*, Summer, vol 1, no 3, pp 12-21

Artner, Alan. "Group show ponders purpose for painting," *Chicago Tribune*, January 18, sec 7, pg 65

Palmer, Laurie. "Reviews: Gaylen Gerber," *Artforum*, March, vol XXIX, no 6, pg 135

Hixson, Kathryn. "Gaylen Gerber in Neutral," *Flash Art*, June 18, vol XXIV, no 159, pg 116-7

____. "The Subject is the Object: The Legacies of Minimalism," *New Art Examiner*, May, pp 29-33

1990

Ostrow, Saul. "Repetition and Replication: Strategies for the Last Painting" exhibition catalogue

Hixson, Kathryn. "Gaylen Gerber" exhibition catalogue

McCracken, David. "Gallery Scene," *Chicago Tribune*, December 28, pg 54

Kalina, Richard. "Gaylen Gerber at Jamie Wolff Gallery," *Teme Celeste*, July/October, no 26, pg 65

Decter, Joshua. "Reviews," *ArtsMagazine*, September, vol 65, no 1, pg 94

Muhr, Peter. "Reviews: Vienna," *Flash Art*, March/April, no 151, pg 156

____. "Gaylen Gerber at Galerie Nächst St. Stephan, Wien," *Artis*, February, pg 50

1989

Hixson, Kathryn. "Reviews: Gaylen Gerber," *Arts Magazine*, November, vol 64, no 3, pg 111

Barckert, Lynda. "Chicago: Gaylen Gerber," *New Art Examiner*, October

Scanlan, Joe. "Problems with Reading Rereading," *Artforum*, September, vol 28, no 1, pg 151

Artner, Alan. "Gaylen Gerber and His Grays: The Ultimate Neutrality," *Chicago Tribune*, June 8, sec 5, pg 9

McCracken, David. "Monochrome Paintings Provoke Question," *Chicago Tribune*, June 16, sec 7, pg 60

____. "Artists Share Thoughts on Warhol Exhibit," *Chicago Tribune*, August 4, sec 7, pg 54

Gamble, Alison. "The Myths that Work: Beneath the Surfaces of Chicago Art," *New Art Examiner*, May, pp 22-25

Milan, Italy Chamber of Commerce, Trade, Industry and Agriculture exhibition catalogue ("Prima Visione: New Experiences by Young Italian and American Artists")

Fernandes, Joyce. "Chicago Works: Art from the Windy City," Bruce Gallery, Edinboro University of Pennsylvania, Erie Art Museum (catalogue)

Hixson, Kathryn. "Gaylen Gerber," *Arts Magazine*, October, vol 62, no 2, pg 62

1988

Hixson, Kathryn. "Cool, Conceptual, Controversial," *New Art Examiner*, May, vol 15, no 9, pp. 30-33

Artner, Alan. "At the Galleries: Gaylen Gerber," *Chicago Tribune*, June 2, sec 5, pg 11B

Brown, Daniel. "New Chicago: Quiet and Deliberate," *Dialogue*, July/August, vol 11, no 4, pp 39-40

McCracken, David. "Still Lifes Show They Can Move the Viewer," *Chicago Tribune*, June 24, sec 7, pg 58

1987

Bonesteel, Michael. "Medium Cool: New Chicago Abstraction," *Art in America*, December, vol 75, no 12

Westerbeck, Colin. "Pedant's Progress," *Chicago Reader*, July 10, sec 1, pp 38 & 43

1985

Bone, James. "Peripheral Vision: Gaylen Gerber at vanStraaten Gallery," *Chicago Reader*, April 19, pp 2-43

1980

Upshaw, Leon R. "Gaylen Gerber at One Illinois Center," *New Art Examiner*, October, vol 7, pg 48

Photo Credits

page 3
Installation,
Documenta IX, 1992
Eugenia Gerber

pages 5, 9, 11, 17, 20,
22, 24
Tom Van Eynde

pages 12, 14, 15
Eugenia Gerber

page 6
Wolff Gallery

page 7
Chistoph Scharff

page 10
Courtesy Daniel Buren

pages 16, 19
Elisabeth Madlener

page 27
Mark Ballogg,
Steinkamp/Ballogg

Gaylen Gerber would like to acknowledge and thank Kathryn Hixson, Irene Tsatsos, and Phillip Gerber for their assistance in organizing this catalogue as well as Howard and Donna Stone for their generous and continued support in realizing this project.

ISBN 0-941548-31-7
The Renaissance
Society at the
University of Chicago

©1995
The Renaissance
Society at the
University of Chicago

Designed by
JNL Graphic Design,
Chicago

Edited by
Kathryn Hixson
and Gaylen Gerber

Printed by
Wicklander Printing,
Chicago